The Learning Works

*Editing and Typography by
Clark Editorial & Design*

Copyright © 1996
The Learning Works, Inc.
Santa Barbara, California 93160

Library of Congress Catalog Number:
96-077883

ISBN 0-88160-295-7
LW 365

Printed in the United States of America.

Introduction

SUPERDOODLES are books that provide easy, step-by-step instructions for super line drawings. The insects in this book may be sketched large for murals or posters, or small for bookmarks and flip books. They may be used individually in separate pictures or combined to create scenes of various habitats.

As you follow the steps, draw in pencil. Dotted lines appear in some steps. Make these lines light so that they can be easily erased later. Finish your drawing by going over it with a colored pencil, crayon, or felt-tipped pen. You may wish to color your insects realistically, or use your imagination.

If you enjoy this book, look for other **Learning Works SUPERDOODLES**. Titles in this series are *Dinosaurs*, *Endangered Animals*, *Mammals*, *Marine Life*, *Pets*, *Rain Forest*, *Reptiles*, *Sports*, *Vehicles*, and *Zoo Animals*.

Atlas moth

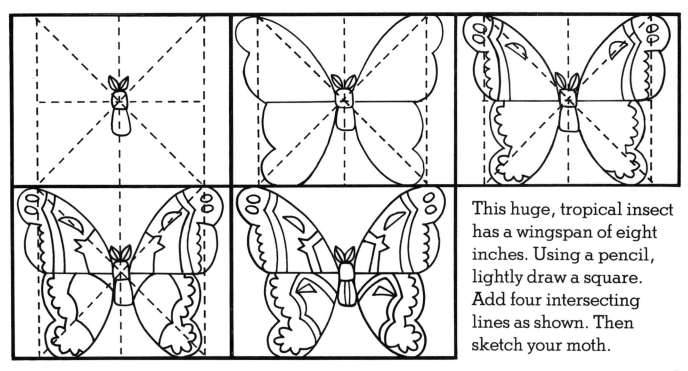

This huge, tropical insect has a wingspan of eight inches. Using a pencil, lightly draw a square. Add four intersecting lines as shown. Then sketch your moth.

cave cricket

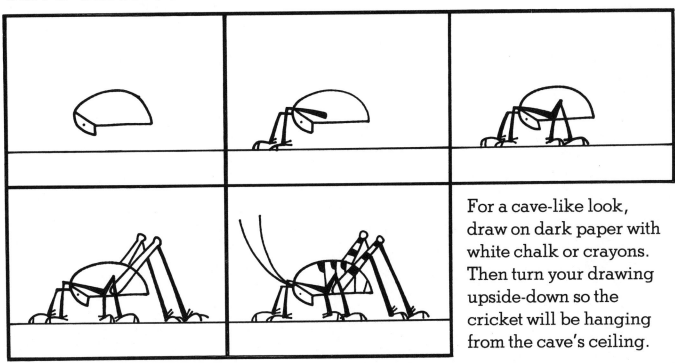

For a cave-like look, draw on dark paper with white chalk or crayons. Then turn your drawing upside-down so the cricket will be hanging from the cave's ceiling.

chestnut weevil

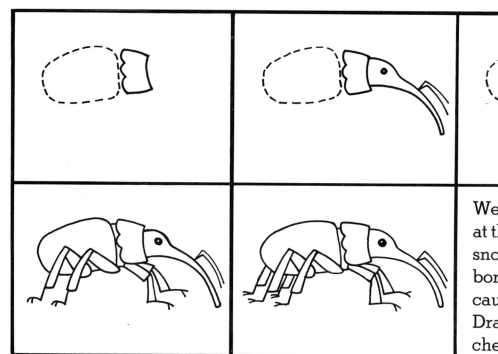

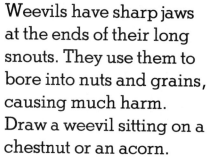

Weevils have sharp jaws at the ends of their long snouts. They use them to bore into nuts and grains, causing much harm. Draw a weevil sitting on a chestnut or an acorn.

cicada

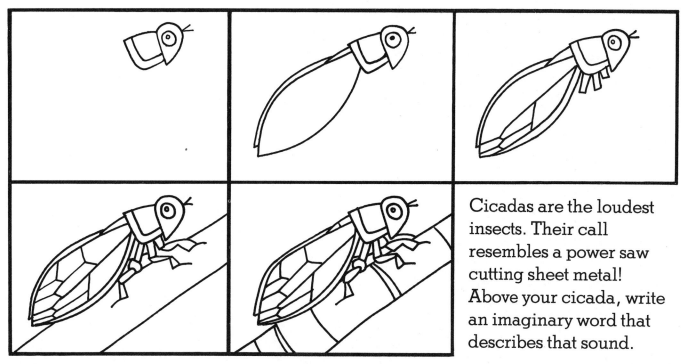

Cicadas are the loudest insects. Their call resembles a power saw cutting sheet metal! Above your cicada, write an imaginary word that describes that sound.

cockroach

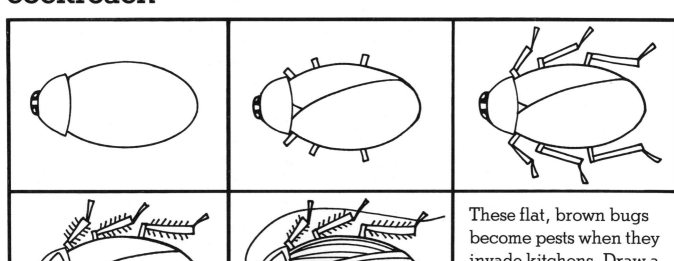

These flat, brown bugs become pests when they invade kitchens. Draw a cockroach sitting near one of your favorite foods, such as a piece of pizza, pie, or cake.

crane fly

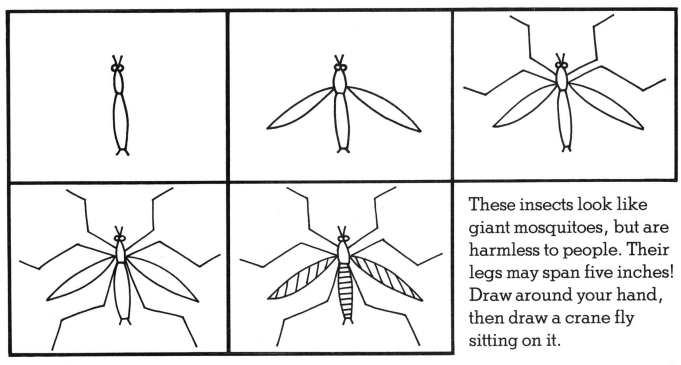

These insects look like giant mosquitoes, but are harmless to people. Their legs may span five inches! Draw around your hand, then draw a crane fly sitting on it.

dragonfly

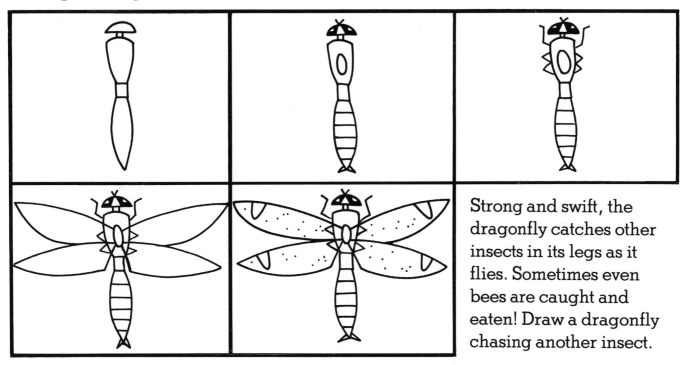

Strong and swift, the dragonfly catches other insects in its legs as it flies. Sometimes even bees are caught and eaten! Draw a dragonfly chasing another insect.

earwig

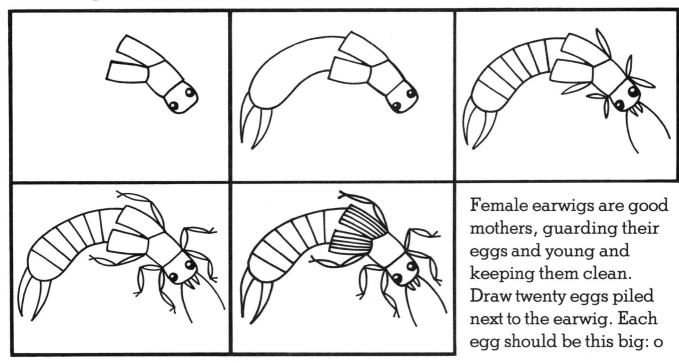

Female earwigs are good mothers, guarding their eggs and young and keeping them clean. Draw twenty eggs piled next to the earwig. Each egg should be this big: o

fairy fly

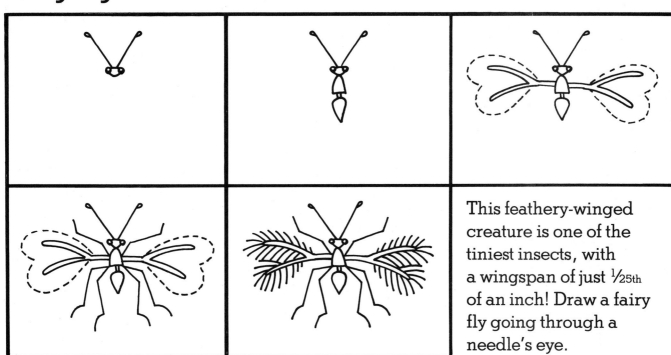

This feathery-winged creature is one of the tiniest insects, with a wingspan of just $\frac{1}{25}$th of an inch! Draw a fairy fly going through a needle's eye.

firefly

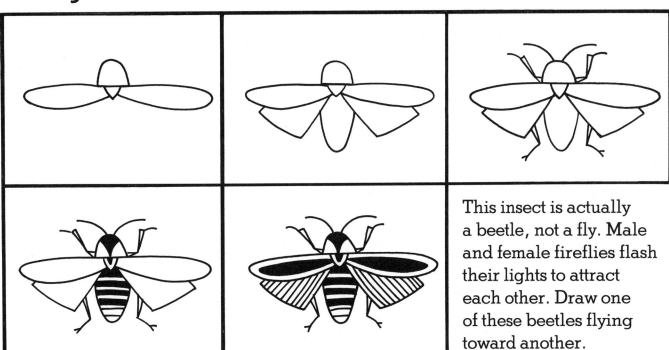

This insect is actually a beetle, not a fly. Male and female fireflies flash their lights to attract each other. Draw one of these beetles flying toward another.

giant water bug

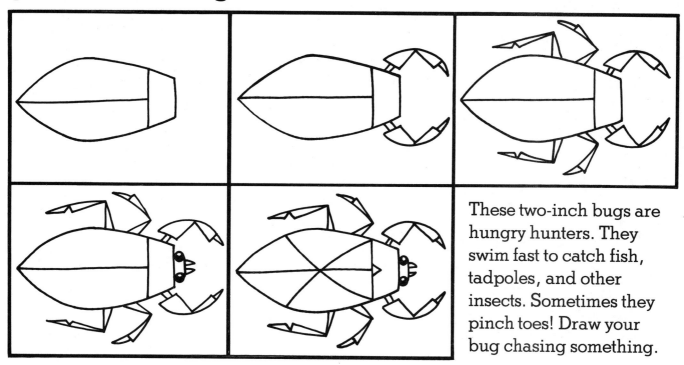

These two-inch bugs are hungry hunters. They swim fast to catch fish, tadpoles, and other insects. Sometimes they pinch toes! Draw your bug chasing something.

Goliath beetle

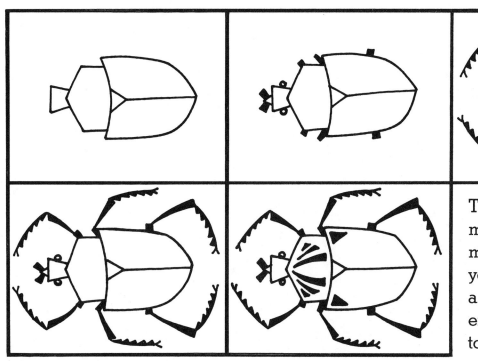

This huge, strong beetle may weigh 3½ ounces—as much as 35 pennies! Use your drawing to design a bumper sticker that encourages people to learn about insects.

grasshopper

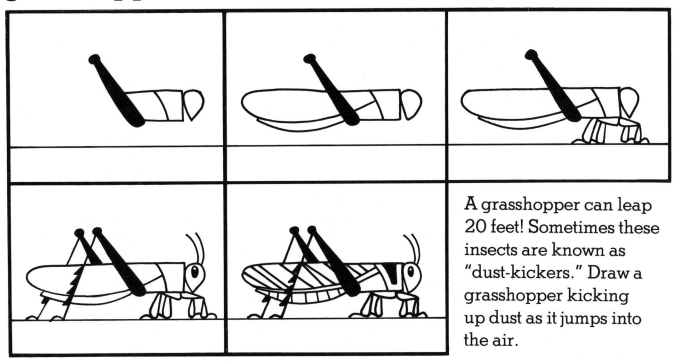

A grasshopper can leap 20 feet! Sometimes these insects are known as "dust-kickers." Draw a grasshopper kicking up dust as it jumps into the air.

harlequin bug

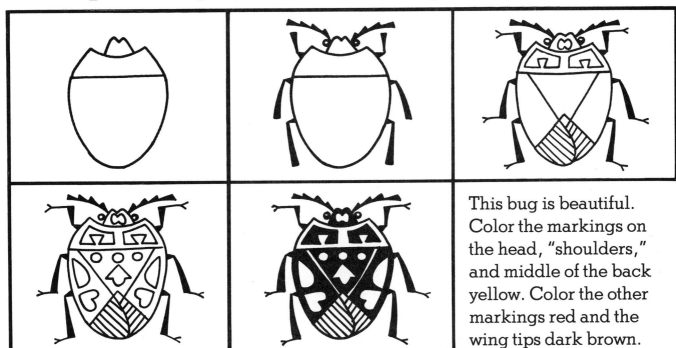

This bug is beautiful. Color the markings on the head, "shoulders," and middle of the back yellow. Color the other markings red and the wing tips dark brown.

ichneumon

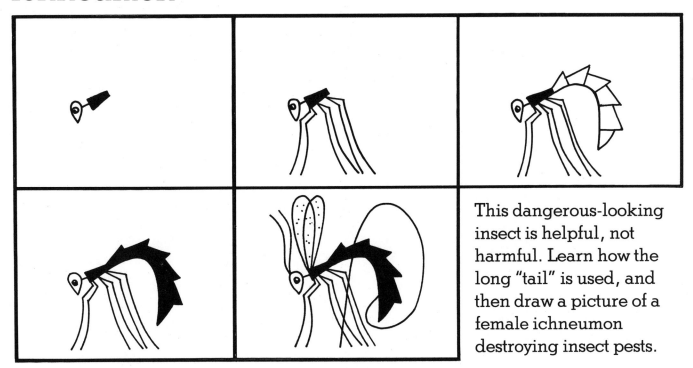

This dangerous-looking insect is helpful, not harmful. Learn how the long "tail" is used, and then draw a picture of a female ichneumon destroying insect pests.

ladybugs (five varieties)

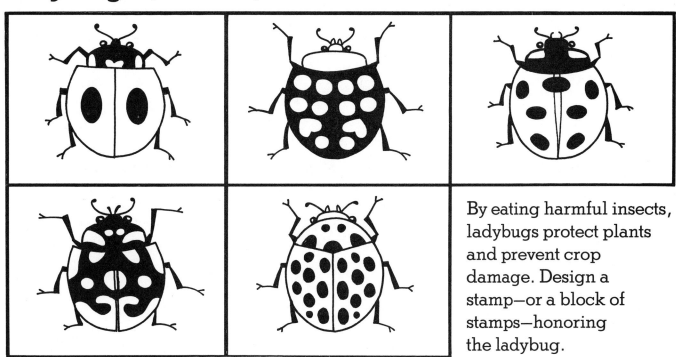

By eating harmful insects, ladybugs protect plants and prevent crop damage. Design a stamp—or a block of stamps—honoring the ladybug.

leaf butterfly

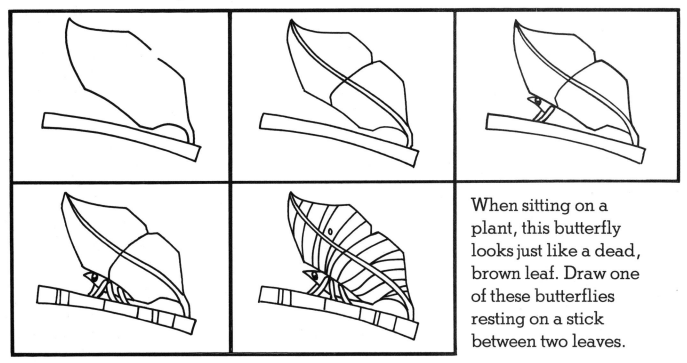

When sitting on a plant, this butterfly looks just like a dead, brown leaf. Draw one of these butterflies resting on a stick between two leaves.

leaf-cutter ant

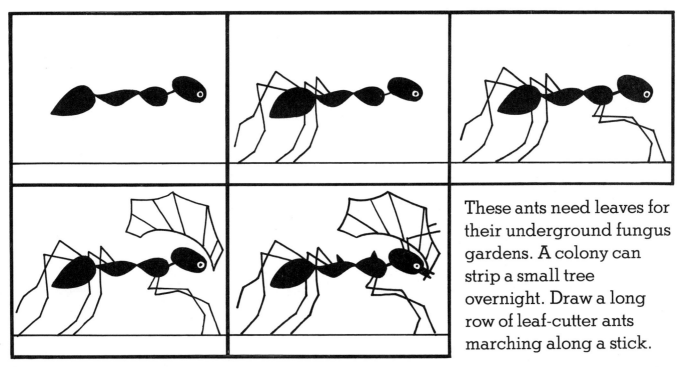

These ants need leaves for their underground fungus gardens. A colony can strip a small tree overnight. Draw a long row of leaf-cutter ants marching along a stick.

longhorn beetle

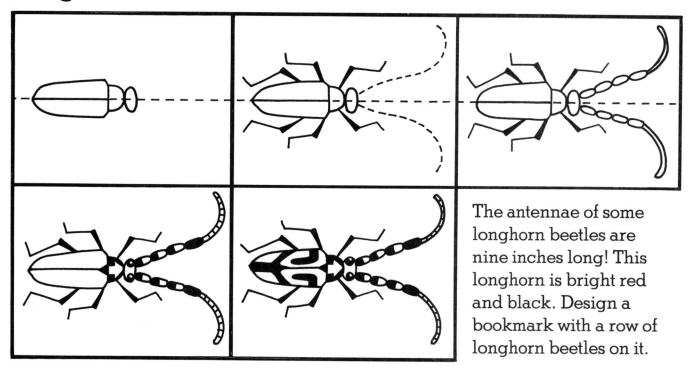

The antennae of some longhorn beetles are nine inches long! This longhorn is bright red and black. Design a bookmark with a row of longhorn beetles on it.

luna moth

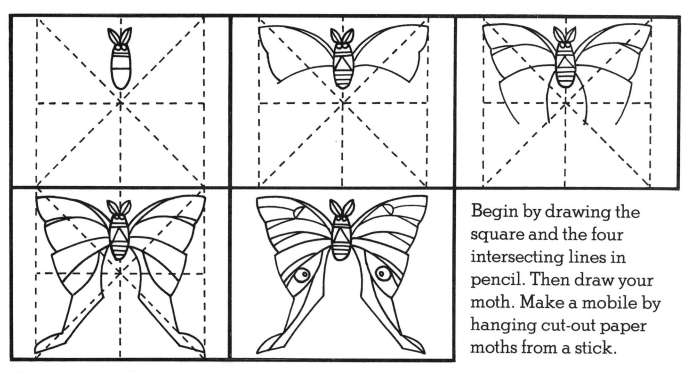

Begin by drawing the square and the four intersecting lines in pencil. Then draw your moth. Make a mobile by hanging cut-out paper moths from a stick.

morpho butterfly

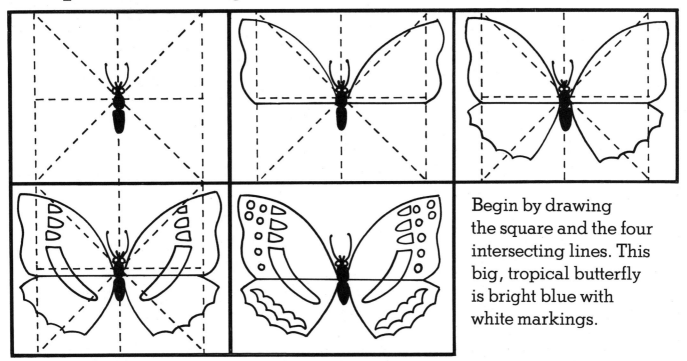

Begin by drawing the square and the four intersecting lines. This big, tropical butterfly is bright blue with white markings.

potter wasp

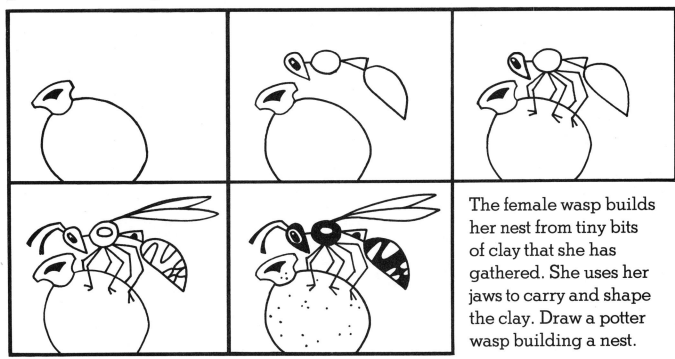

The female wasp builds her nest from tiny bits of clay that she has gathered. She uses her jaws to carry and shape the clay. Draw a potter wasp building a nest.

praying mantis

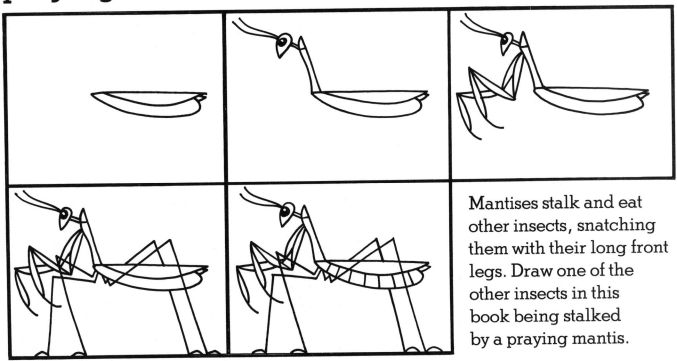

Mantises stalk and eat other insects, snatching them with their long front legs. Draw one of the other insects in this book being stalked by a praying mantis.

snake fly

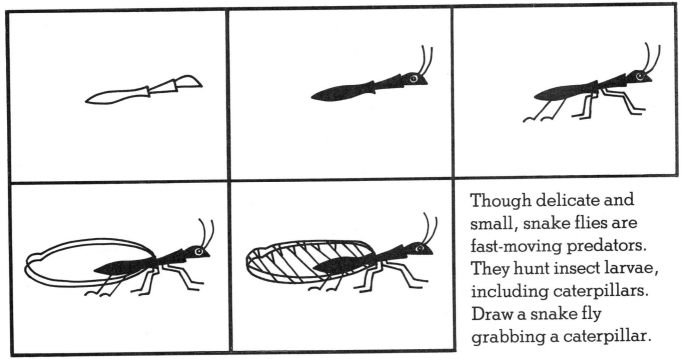

Though delicate and small, snake flies are fast-moving predators. They hunt insect larvae, including caterpillars. Draw a snake fly grabbing a caterpillar.

squash bug

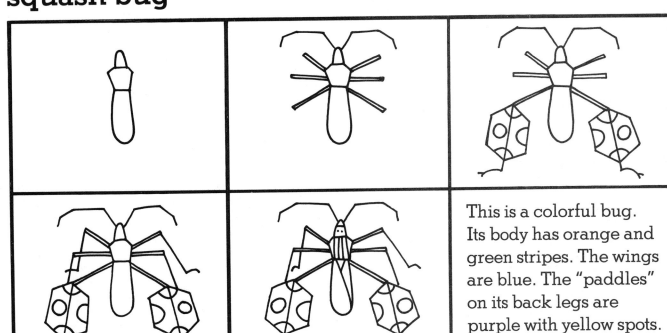

This is a colorful bug. Its body has orange and green stripes. The wings are blue. The "paddles" on its back legs are purple with yellow spots. Color your bug.

stag beetle

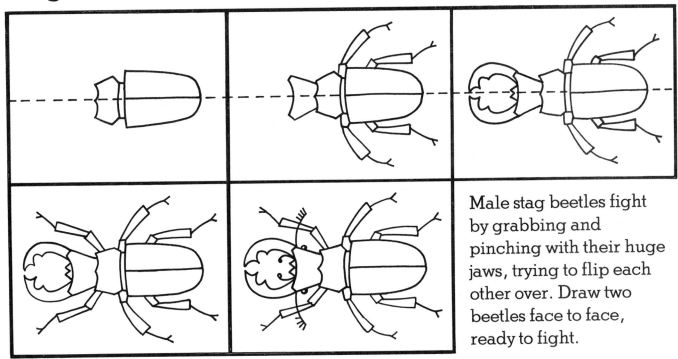

Male stag beetles fight by grabbing and pinching with their huge jaws, trying to flip each other over. Draw two beetles face to face, ready to fight.

stick insect

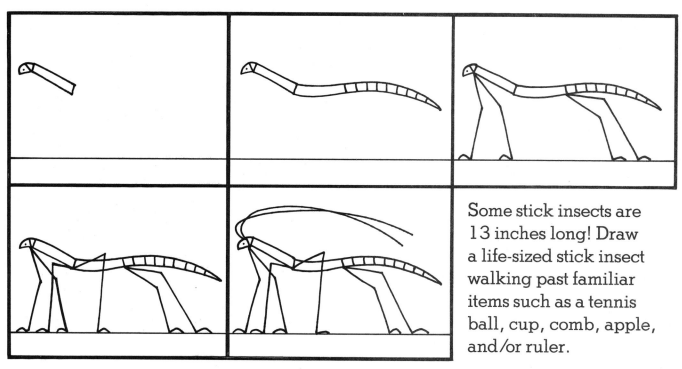

Some stick insects are 13 inches long! Draw a life-sized stick insect walking past familiar items such as a tennis ball, cup, comb, apple, and/or ruler.

treehoppers (five varieties)

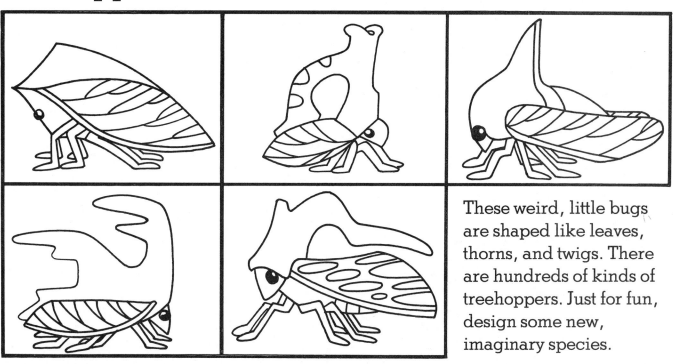

These weird, little bugs
are shaped like leaves,
thorns, and twigs. There
are hundreds of kinds of
treehoppers. Just for fun,
design some new,
imaginary species.

violin beetle

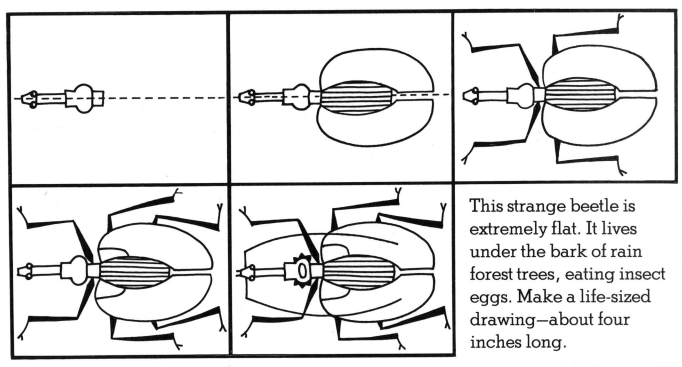

This strange beetle is extremely flat. It lives under the bark of rain forest trees, eating insect eggs. Make a life-sized drawing—about four inches long.

yellowjacket

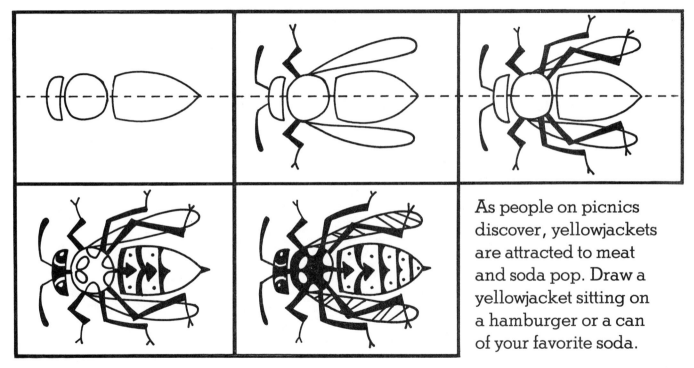

As people on picnics discover, yellowjackets are attracted to meat and soda pop. Draw a yellowjacket sitting on a hamburger or a can of your favorite soda.